SALE
HISTORY TOUR

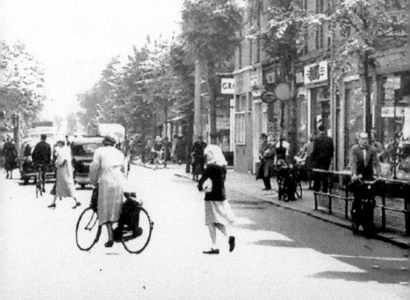

For Sarah, my wife.
Love forever.

First published 2022

Amberley Publishing
The Hill, Stroud,
Gloucestershire, GL5 4EP
www.amberley-books.com

Copyright © Steven Dickens, 2022
Map contains Ordnance Survey data
© Crown copyright and database
right [2022]

The right of Steven Dickens to be
identified as the Author of this work
has been asserted in accordance with
the Copyrights, Designs and Patents
Act 1988.

ISBN 978 1 3981 0143 2 (print)
ISBN 978 1 3981 0144 9 (ebook)

British Library Cataloguing in
Publication Data.
A catalogue record for this book is
available from the British Library.

Origination by Amberley Publishing.
Printed in Great Britain.

INTRODUCTION

Sale History Tour relies on some of the resources originally presented in *Sale Through Time*, published in 2013. However, I have made some changes to this material where I feel they are necessary or needed. I divided the original Through Time book into five 'districts', which were approximately equal in area and could be studied as one unit, or individually, if preferred. The first section begins at Crossford Bridge, on the Sale boundary with Stretford, which is also the historic county boundary between Cheshire and Lancashire and takes the reader along Cross Street, onto Washway Road. The next section begins at the Marsland Road junction with Washway Road and takes in Sale and Brooklands Cemetery, Brooklands station, Brooklands Road and ends at Marsland Road, in Sale Moor. The third section begins on Northenden Road, at Sale Moor, continuing out of the town centre, taking in Old Hall Road before heading back towards Sale Moor, in the direction of Sale and including Trinity Methodist Chapel, St Anne's Church and Sale (Worthington) Park. Continuing towards Sale, the Town Hall and the retail sector along School Road form the next district, which ends at School Road's busy junction with Cross Street, Washway Road and Ashton Lane. The final section takes in the Ashton on Mersey area, which became a part of the district of Sale after its amalgamation in 1930. These five 'districts' remain relevant to the study of the new book. The physical configuration of the town continues to change in 2020, notably with the loss of the Magistrates' Court on the corner of Ashton Lane and Cross Street and the demolition of the Waggon & Horses public house on Cross Street, for a modern development. Despite these changes, enough still remains of the old town centre of Sale to be recognisable to the more mature resident, as depicted through the pages of *Sale History Tour*. These remnants, as represented within the pages of the book, will also be of great historical interest to the newer resident. Whatever their reasons for exploring this book however, I hope that the reader enjoys this selection of photographs from Sale's unique past.

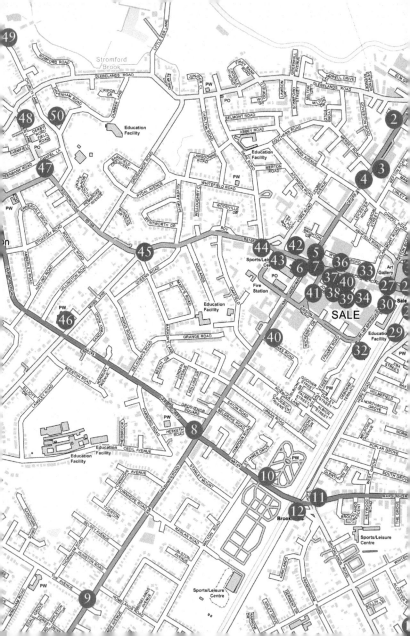

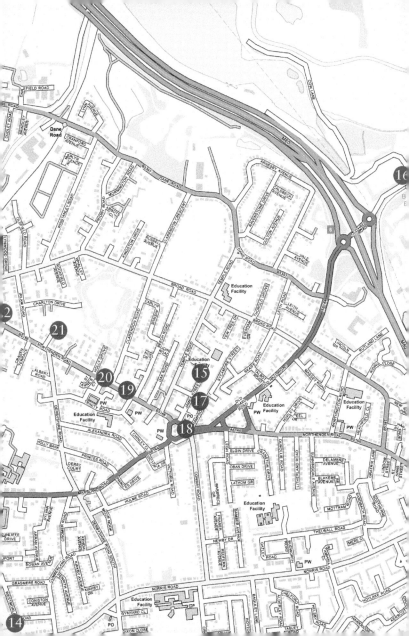

KEY

1. THE OLD TOLL BAR, CROSSFORD BRIDGE

The toll house at Crossford Bridge was built in 1765 on a much narrower Chester Road, which was widened in 1961. It was situated where the bus shelter stood in 2012. This was just inside the Ashton boundary, next to the Bridge Inn, at Stretford. The Crossford toll bar was abolished on 31 October 1885, with the Bridge Inn being demolished in the 1980s. The whole area was later occupied by TGI Fridays, on the right of the 2012 inset photograph. Nearby Crossford Bridge was first referred to in 1538.

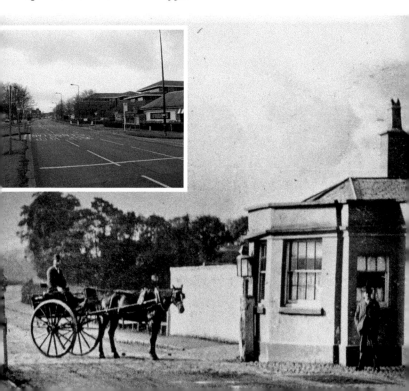

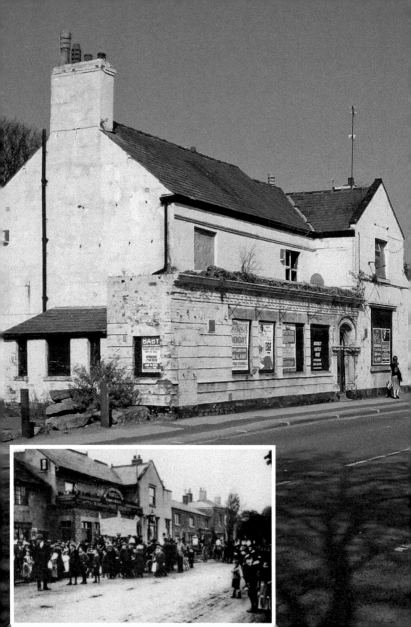

2. THE WAGGON & HORSES

When I photographed this location in 2012, the Waggon & Horses public house had been closed since the early 2000s, deteriorating beyond repair, even though it was situated on a prime development site. At the time, it was unlikely that restoration would preserve it and it remained a monument to the town's historic past. Photographed in May 1902 (inset), the Waggon & Horses is shown in more prosperous times, with Howorth Bailey the landlord and the parade of an ox roast to celebrate the end of the Boer War. In 2020 a new development occupies the site of the former public house.

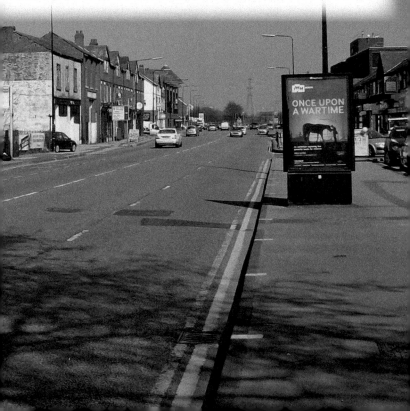

3. EYEBROW COTTAGE, CROSS STREET

The oldest building in Sale and one of the earliest brick-built buildings in the area, Eyebrow Cottage was a yeoman's farmhouse, built around 1670. In 1806 it was the home of Captain John Moore, who raised the Sale Volunteers in 1803. The distinctive sills above its windows gave the cottage its name, being designed to deflect heavy rainfall in bad weather. In the seventeenth century the area of Cross Street where Eyebrow Cottage stands was a separate village from Sale. The cottage is close to Dane Road, once the site of Sale Priory, a private residence. Until the arrival of the railway in 1849, the centre of Sale had been at Sale Green and its smithy, around Dane Road and Broad Road junctions; according to Swain, the village Pinfold once stood nearby, at the junction of Dane Road and Temple Road.

4. THE VOLUNTEER HOTEL

The Volunteer Hotel opened in 1898, replacing the White Lion, which stood here from 1807 and had been renamed by 1827. The name originates from the Ashton on Mersey and Sale Loyal Volunteers, raised in 1803 at the Plough Inn, Ashton on Mersey. The building next to the Volunteer in 1905 was originally a hay loft and then a grocer's shop. Now surrounded by office blocks, in 1898 the Volunteer's distinctive tower was a dominant point on the Sale landscape. In 2020 the public house valiantly survives on Cross Street, still surrounded by office blocks.

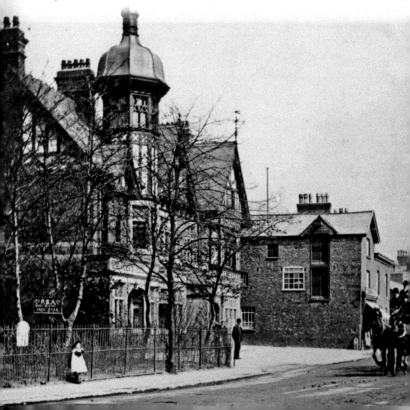

5. CROSS STREET

Cross Street is continuous with Washway Road, formerly Watling Street, the old Roman road linking the Roman settlements at Manchester, Northwich and Chester. School Road is to the left of this photograph, with the Bull's Head Hotel just off camera. Washway Road heads towards Altrincham and the provisions store of John Clarke can just be seen on the extreme right of the photograph of 1903, where there is a gas light. Trees shroud the premises of John Ingham & Sons, photographer, where Ashton Lane forms the corner of Washway Road. Today pedestrian crossing lights control traffic at this very busy junction.

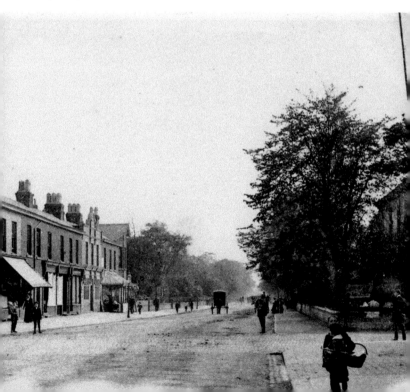

6. WASHWAY ROAD

The Bull's Head Hotel continues to dominate the junction of Washway Road, Cross Street, Ashton Lane and School Road, with the retail premises on the right side of the photograph now replaced by a modern development. Originally they housed the business concern of John Birkenhead, stationer and newsagent, whose photographic record of the area is of immense value to local historians. The left side of the photograph shows the perimeter of John Ingham & Sons, near the Ashton Lane junction.

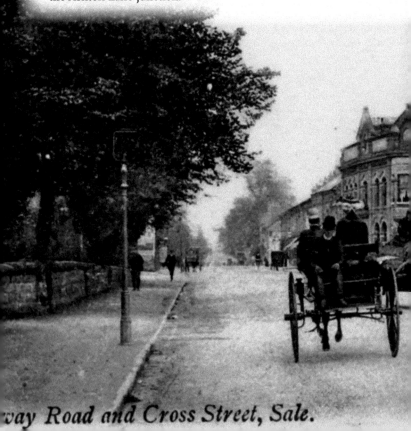

vay Road and Cross Street, Sale.

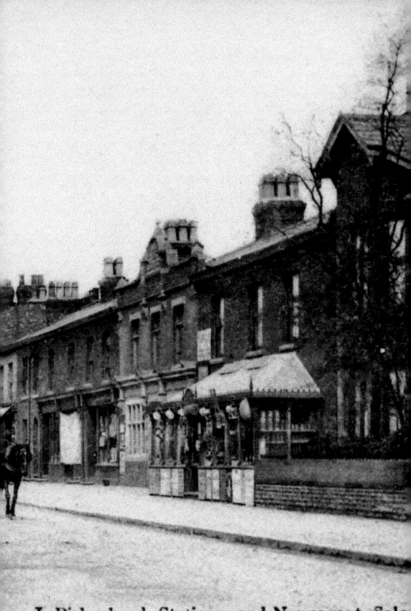

J. Birkenhead, Stationer and Newsagent, Sale

7. WASHWAY ROAD

On the left of the 1965 photograph the original terrace can be seen that once housed the retail premises of John Birkenhead, stationer and newsagent, and later became a post, sorting and telegraph office until 1931. To the right of the photograph is Washway Parade and the Odeon cinema, later a fitness club. Originally the Pyramid Cinema (inset), it opened in 1934, and closed as a cinema in October 1981. The old post office is situated between the trees in the centre. This post office opened on 20 September 1931, despite some initial opposition from local traders.

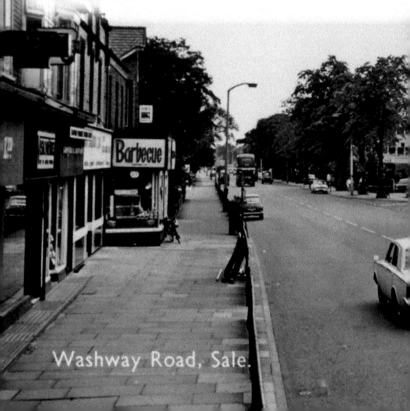

Washway Road, Sale.

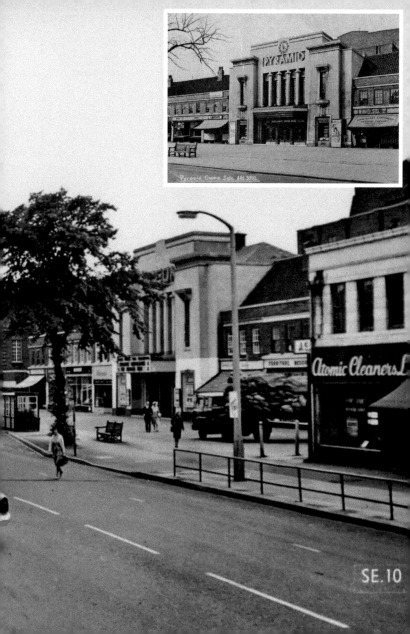

Pyramid Cinema, Sale. ALT 3392.

Atomic Cleaners L

SE.10

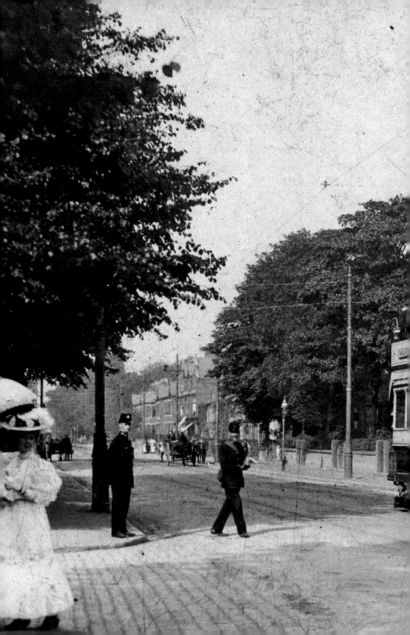

8. WASHWAY ROAD AT ITS JUNCTION WITH MARSLAND ROAD

The year 1906 is significant because on 17 August of this year the tramline to West Timperley was officially opened to the public. Originally the tram service ran from Manchester to Stretford, was extended to Sale and eventually to Altrincham by 1907. The destination of 'Timperley' can be clearly seen on the front of the tram, while a policeman patrols this busy junction. The trees behind the tram remained in 2012, although the cottages have now been demolished. Nearby, the former Sale Lido, also on Washway Road, opened on Wednesday 10 July 1935. Its swimming pool could be covered and used as a dance floor. The complex included a row of shops. Mecca Ltd later renamed it the Locarno Ballroom.

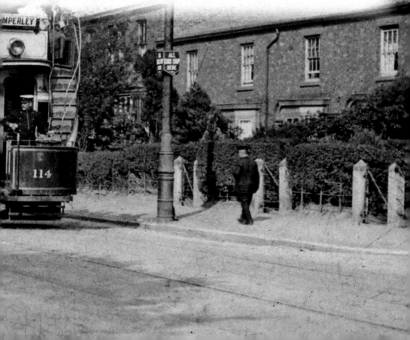

9. WASHWAY ROAD AT ITS JUNCTION WITH THE AVENUE

The Avenue was deliberately built long and straight, the intention of this being to bring the rural countryside of Cheshire into the urban heartlands of Sale. At its junction with Washway Road is a gate and lodge, which was home to a gatekeeper serving the mansions of Oakleigh, Woodheys Grange and Ashleigh. The lodge still has its spire in 1903, which acted as a local landmark at this time, but unfortunately it is no longer standing. The Avenue was established by the land- and property-owning dynasty of Samuel Brooks and was originally known as Brook's Avenue, although there are also references to it as Woodheys Park. Oakleigh, a Victorian property, survives as apartments, but many of the Avenue's properties date from the early twentieth century. It is also home to the Avenue Methodist church.

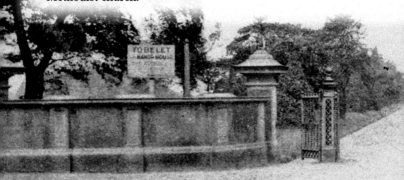

16. *The Avenue, Ashton-on-Mersey, Sale.*

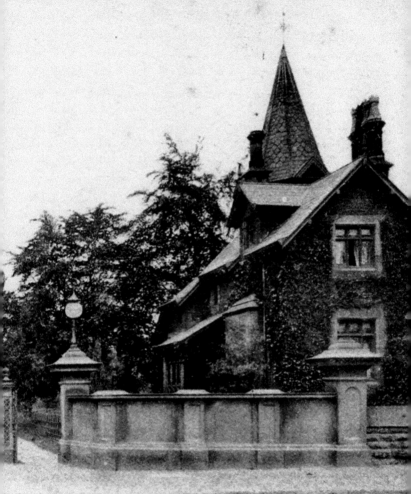

J. Birkenhead, Stationer and Newsagent, Sale

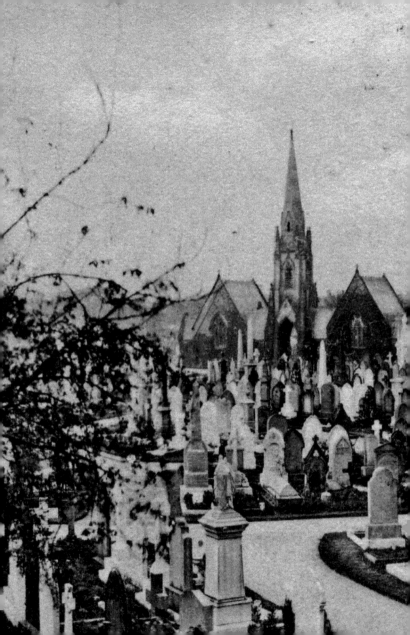

10. SALE AND BROOKLANDS CEMETERY

Sale and Brooklands Cemetery opened in 1862 and stretches across both sides of Marsland Road, being linked by an underground tunnel. The north side of the cemetery is older and houses a chapel, shown in the photographs. It was the first public cemetery serving the south of the Manchester conurbation, with many notable families buried here. Scientist James Prescott Joule, Richard Pankhurst of the suffragette family, newspaper magnate Edward Hulton and Samuel Lord all have their memorials here.

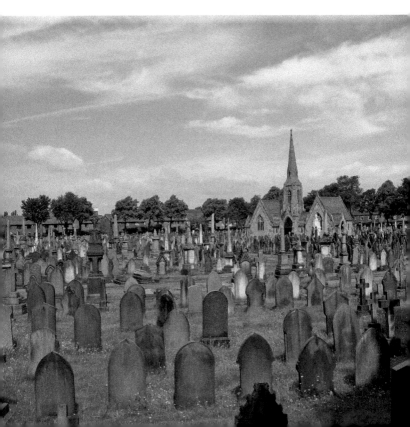

11. THE BROOKLANDS HOTEL

Marsland House now occupies the site of the Brooklands Hotel, which was built in 1872 and demolished in 1972. Owned by the Grand Hotel in Manchester, it was used as an annexe. In 1893 the Brooklands Agreement was signed here, and in 1947 it is believed that the comedians Laurel and Hardy stayed at the hotel. The Woodcourt

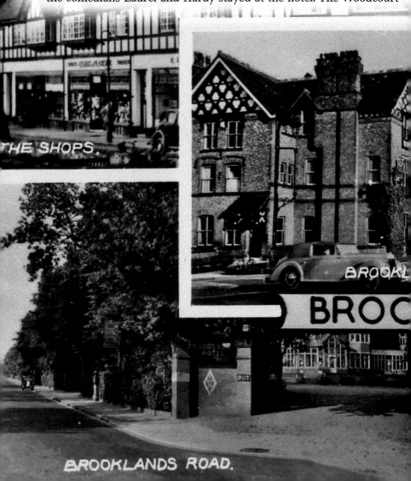

THE SHOPS.

BROOKLANDS ROAD.

Hotel, also shown, has today been demolished. The photograph of Marsland Road looks towards Sale and the Brooklands Hotel, at its junction with Hope Road on the right and Brooklands railway station, at its junction with Brooklands Road, on the left. The shops and Walton Park also form part of this junction, on the left of Brooklands railway station. Today there are traffic lights at this crossroads.

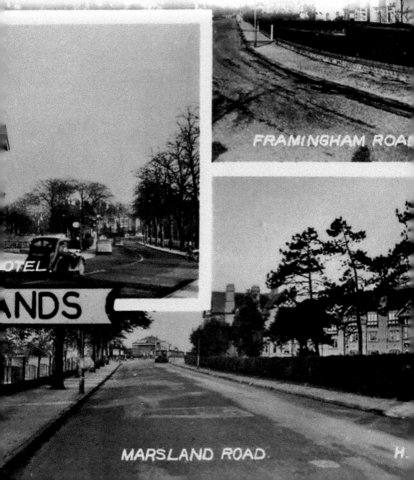

FRAMINGHAM ROAD

MARSLAND ROAD.

H.

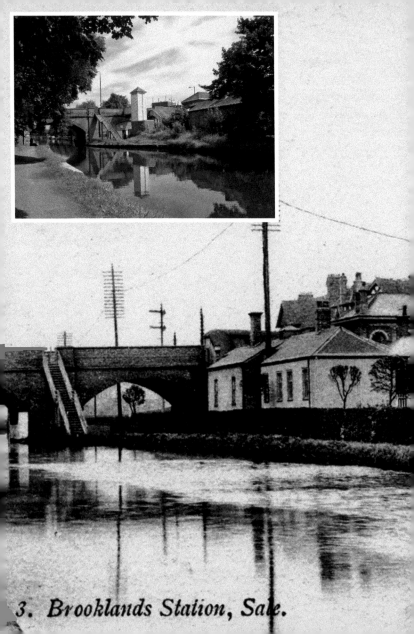

3. Brooklands Station, Sale.

12. BROOKLANDS STATION AND THE BRIDGEWATER CANAL

Brooklands station was opened on 1 December 1859 by the Manchester, South Junction & Altrincham Railway. The station is Grade II listed and was constructed and named following the influence of Manchester banker Samuel Brooks, who sold the site to the railway company. The date 24 December 1991 was the last day that British Rail electric trains ran this route, which reopened on 15 June 1992 as a Metrolink tramline. The tower in the 2012 inset photograph houses a lift.

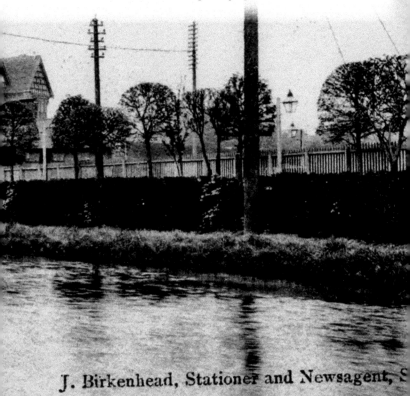

J. Birkenhead, Stationer and Newsagent, S

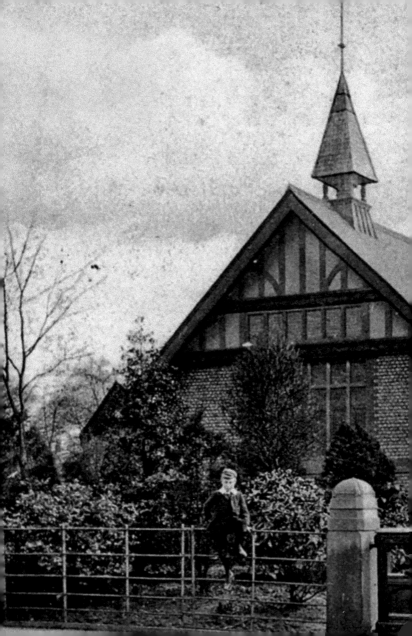

13. ST JOHN THE DIVINE

Brooklands was named after Manchester entrepreneur Samuel Brooks, who purchased the land here in 1856. His church for the district, St John the Divine, was built by Manchester architect Alfred Waterhouse between 1864 and 1868, opening on 9 April 1868. The church has changed little, although a small bell fleche was destroyed by fire in 1945. The church hall, behind the parish church, was built in 1968 and replaced the parish room on Marsland Road, shown here.

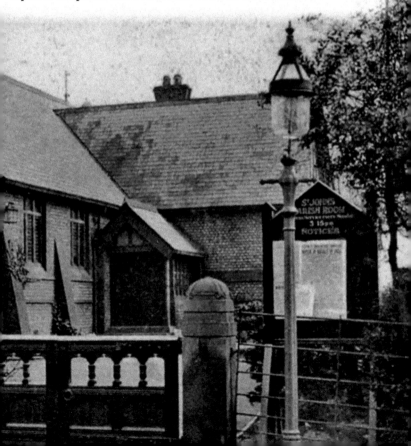

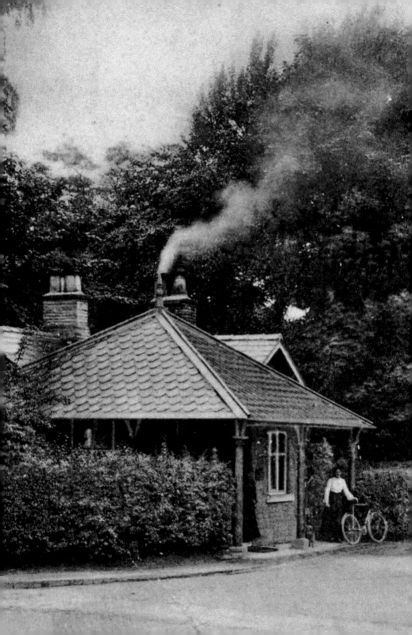

14. THE TOLL BAR AT BROOKLANDS ROAD

Samuel Brooks' original concept was the construction of a private avenue from Brooklands station, at Marsland's Bridge, and the provision of large mansion properties along it – now a conservation area. This privacy was to be augmented by a toll gate at the junction of Brooklands Road, with the former Turnpike Road connecting Altrincham and Stockport. This photograph looks along Brooklands Road, towards Sale. Today, the gatehouse remains, although the area is now dominated by a large traffic roundabout.

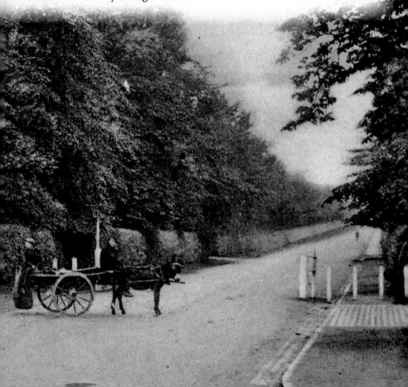

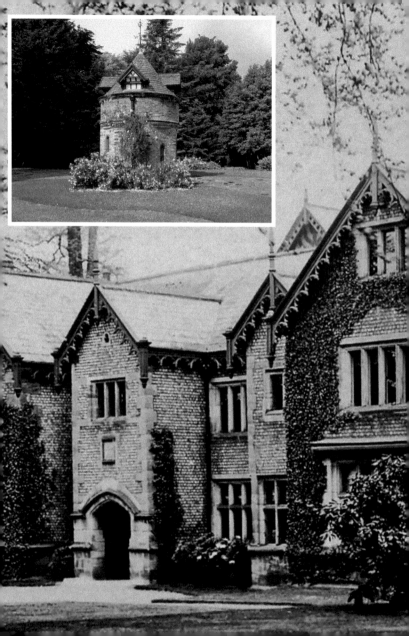

15. SALE OLD HALL

In 1900 Sale Old Hall was the residence of Sir William Bailey, who erected the 'Togo' pagoda in its grounds. The hall and ancillary buildings were situated on the south side of Rifle Road, at its junction with Old Hall Road. They were demolished in 1920, but the Dovecote (inset), built in 1895, remained, later being located on a motorway roundabout. When the M60 was widened it was moved to a new location at Walkden Gardens, on Marsland Road. The listed Sale Hotel, on Marsland Road, is opposite the Dovecote. It was built in 1879 as part of Moorfield Gardens, later Sale Botanical Gardens, which closed in 1896. The hotel's tower was built as a vantage point.

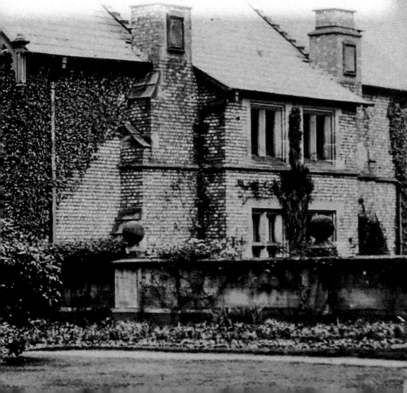

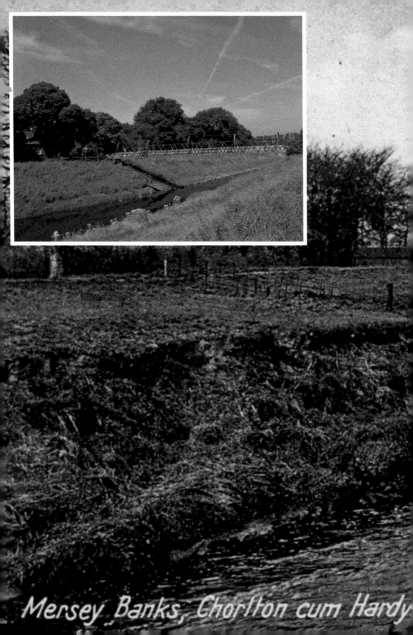

Mersey Banks, Chorlton cum Hardy

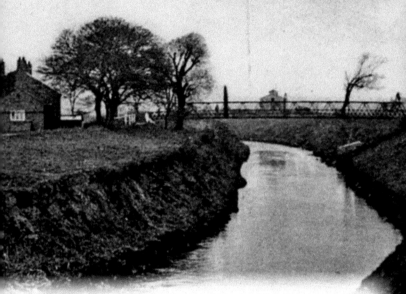

16. JACKSON'S BOAT AND FOOTBRIDGE

The original building dates from 1663, with the present public house, built around 1800, incorporating some older structures. Originally known as the Bridge Inn, or Jackson's (Ferry) Boat, the ferry that used to cross the River Mersey at this point was discontinued in 1816, when a wooden bridge was built. This was swept away in a storm and replaced by an iron bridge in 1881. In the eighteenth century it was a regular meeting place of the Jacobites. In 2020 the Metrolink tram system passes close by.

17. SALE NEW HALL

In 1688 William Massey, of the feudal landowning family, built a house in Fairy Lane known as Sale New Hall. It was used as a farmhouse for most of its life and was demolished in 1953. Its site is now covered by the M60 motorway. However, the Massey family and their historic contribution to the Sale area remain noted, as part of their family insignia consisted of a bull's head, after which the public house on Cross Street is named. Nearby, at the junction of Wythenshawe Road and Northenden Road, there is a private dwelling of late eighteenth- or early nineteenth-century construction, which became the Nag's Head public house in 1869. Today, only the central section remains, as a private dwelling once more.

Sale Hall

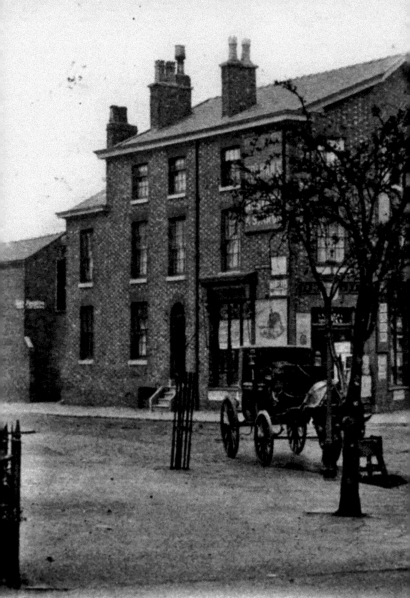

Northenden Road and Mar land's Road Sa

18. NORTHENDEN ROAD AND MARSLAND ROAD JUNCTION

Originally belonging to Thomas Wilkinson and established in 1856, the featured retail premises were used as a general store and post office in the late nineteenth century. Those same premises, photographed in 1903, were inherited by John Wood, grocer, at No. 170 Northenden Road, formerly Moor Lane. Northenden Road continues straight through Sale Moor, with Marsland Road branching to the left, near the Legh Arms public house. By the early twenty-first century the change of business use here connotes a sign of the times, the building later housing a debt recovery concern. Nearby, the Manchester Certified Industrial School for Girls, on Northenden Road, was built in 1876 and demolished in 1985. It accommodated 100 girls, occupying a site now covered by Pimmcroft Way.

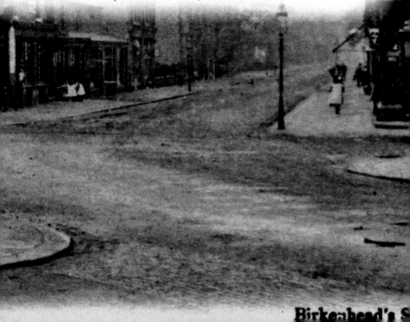

Birkenhead's S

19. TRINITY METHODIST CHAPEL

Trinity Methodist Chapel opened on 30 September 1875 when the congregation from Broad Lane Chapel moved into its new premises. In 1884 a new Sunday school building was added, to be replaced in the 1960s by a large extension. In 1980 the main chapel building was sold and became an auction house. There were further renovations, taking place in 2006, with the main chapel building (facing Northenden Road) converted for commercial use. The chapel entrance is now in Trinity Road.

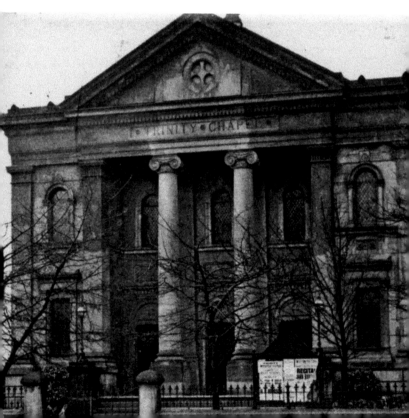

20. ST ANNE'S CHURCH

Today known as St Anne's, Sale, with St Francis, Sale Moor, St Anne's Church opened on 14 July 1854. The church was built on a site presented by entrepreneur Samuel Brooks, who also made an initial donation to the church of £500. The architect was William Hayley of Manchester and the total cost of the building came to £4,200, nearly all raised by the voluntary contributions of Sale residents. Further alterations and additions were made in 1864 and 1887. St Anne's School was built in 1971 on the site of the bowling green. It is adjacent to the current church hall, which was part of the original school, built in 1863.

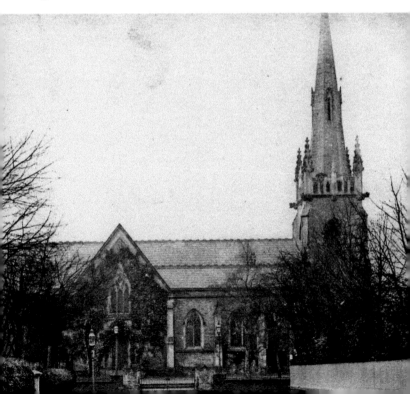

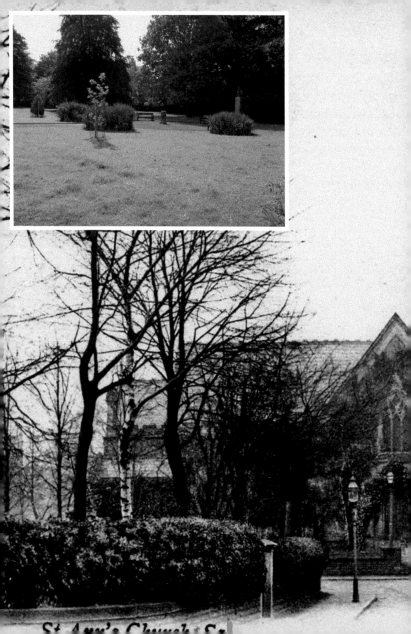

St. Ann's Church, Sq.

21. WORTHINGTON PARK GATES AND LODGE

Sale Park opened on 30 June 1900 and was renamed Worthington Park in 1949, after Mary Worthington of Sale Lodge, the widow of James Worthington, who had been a member of the Sale Local Board. Mary Worthington's initially anonymous financial donation led to the park's establishment. There were 2,500 Sunday school children invited to attend the park's opening. The lodge formerly housed a full-time park keeper and, according to the date stone, was built in 1898. Worthington Park's original facilities included a bandstand, ornamental lake and summer houses. It covers 16.5 acres and has a memorial to Sale scientist James Prescott Joule (1818–89, see inset), who lived for many years on Wardle Road. It was also home to a stone lion, later relocated.

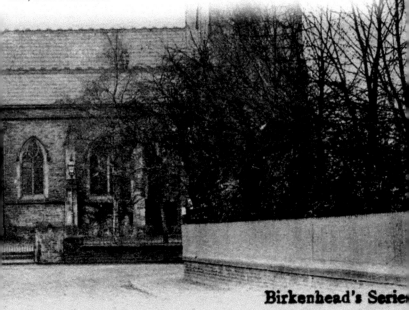

Birkenhead's Series

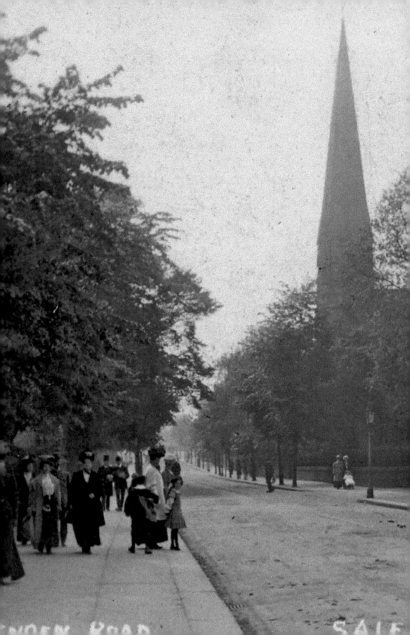

NDEN ROAD SALE

22. SALE PRESBYTERIAN CHURCH

Sale Presbyterian Church, at the junction of Northenden Road and Woodlands Road, was built in 1874 and redeveloped in 1968. The distinctive church spire may have gone but the two red Cheshire sandstone window frames, which were visible high up on the old church building, have been recycled. The rose windows now form part of the structure of Sale United Reformed Church on nearby Montague Road. The original site of the church is now an office block. At the junction of Hope Road and Montague Road is another place of worship, St Joseph's Roman Catholic Church, which opened on 10 May 1885.

NEIL'S SERIES. Nº 2040

23. WARDLE ROAD

Rutland House, at No. 12 Wardle Road, was once the home of the famous scientist and physicist James Prescott Joule (1818–89). He lived here for the last seventeen years of his life. Joule's theories led to the joule and the kilojoule becoming the standard measurements for energy. There is a memorial to Joule in Worthington Park and more recently a bar on Northenden Road has been named after its famous one-time resident.

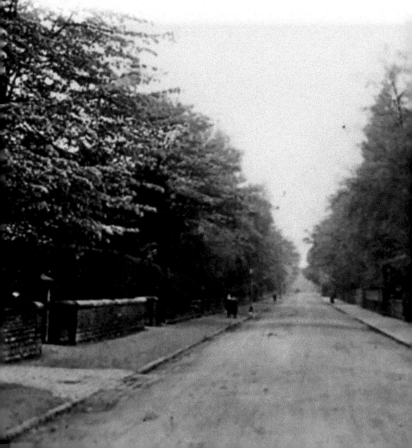

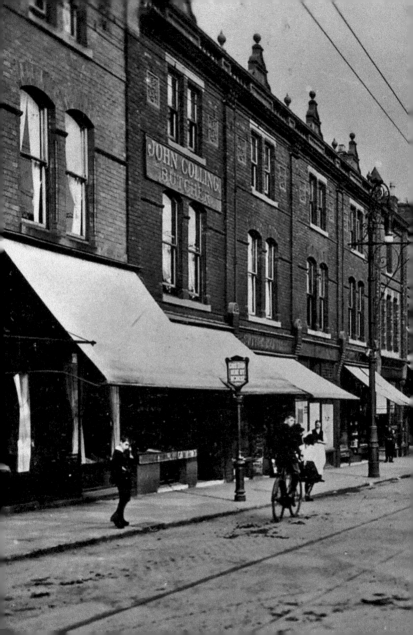

24. NORTHENDEN ROAD

Robert Oxton Bolt CBE (1924–95) was born at No. 13 Northenden Road. His father's furnishing store, which has undergone many changes of use since, now displays a commemorative plaque. Bolt wrote *A Man for All Seasons* and several screenplays, winning an Oscar for the Best Adapted Screenplay. Sale Waterside's Robert Bolt Theatre was named in his honour. Today, the retail premises of 1915 remain, with some modern development at the far end. The spire belongs to Sale Presbyterian Church on Northenden Road, which was known as Moor Lane in 1867.

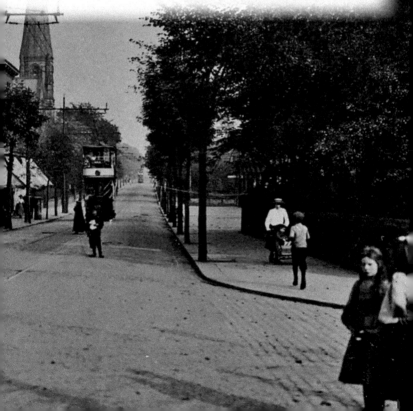

25. NORTHENDEN ROAD AND BROAD ROAD JUNCTION

The shop sign to the left of this 1903 photograph confirms that the premises belong to Jones & Jackson, described in Slater's Directory of 1900 as 'Painters, Furnishers & Decorators and dealers in Japanese goods, &c, &c. Show Rooms: 3 Northenden Road, Sale.' Today the buildings of the former Jones & Jackson shop remain, although the original woodyard later became a bar and live music venue, with traffic lights now at the junction of Broad Road.

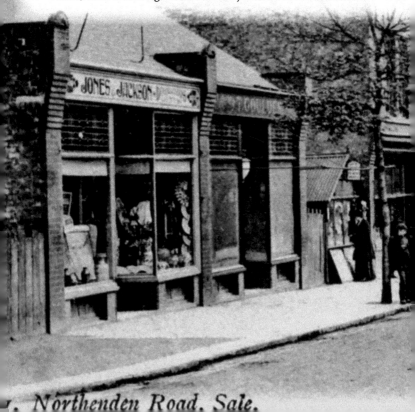

Northenden Road. Sale.

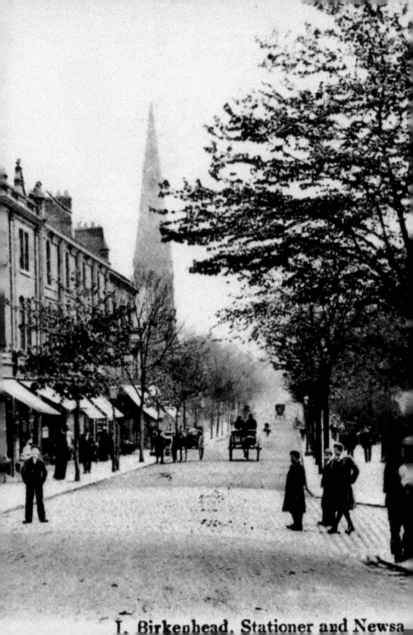

I. Birkenhead, Stationer and Newsa

26. LLOYDS BANK AND HORSE-TAXI RANK

The building in the centre of this *c.* 1902 photograph was Lloyds Bank, which remains virtually unchanged today, although it later became solicitor's premises. The shop premises, known as Tatton Buildings and located to the right of Lloyds Bank, now form part of Sale Town Hall, which officially opened in 1915. The horse-taxi rank served commuters using Sale railway station and retail premises along School Road. There is still a taxi rank outside Sale Metrolink station today.

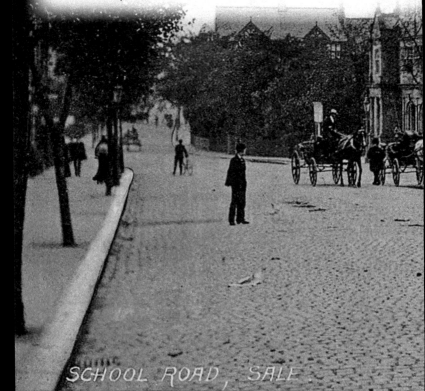

SCHOOL ROAD, SALE

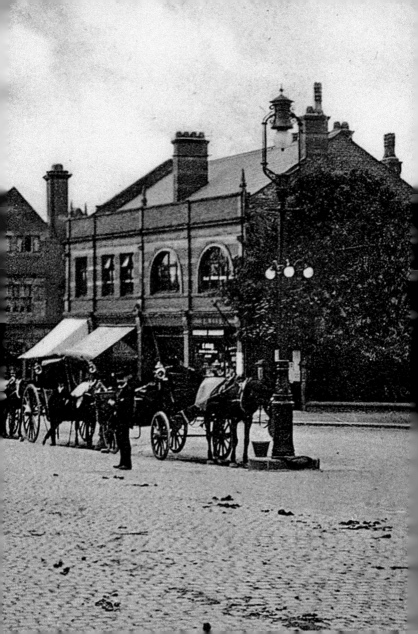

27. SALE TOWNSHIP SCHOOL

The entrance to Sale Township School overlooked School Road. Its distinctive bell tower and three gable ends are just visible through the trees in this 1903 image. Springfield Road School replaced it in June 1907, the site later being used for a bank. The noticeboard directly ahead belongs to the original Sale Town Hall, set back from School Road and rebuilt in 1915, on the same site. Sale Market and Fire Station occupied part of this site for a time.

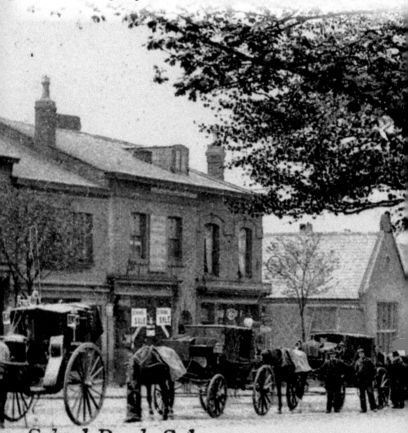

School Road, Sale.

Birkenhead, Stationer and Newsage

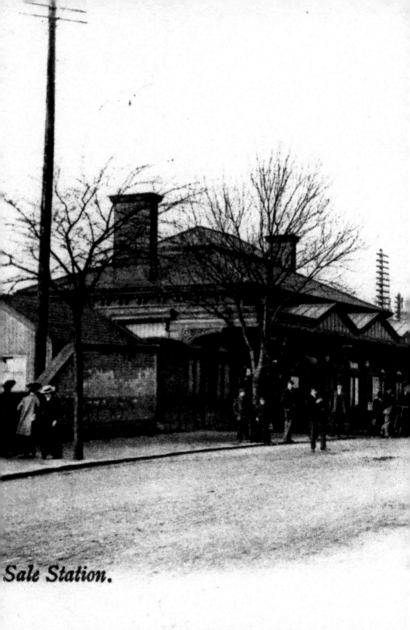

Sale Station.

28. SALE STATION

Opened on 20 July 1849 as the Manchester, South Junction & Altrincham Railway, *Flora* was the first engine working this route. John Brogden of Sale built the Manchester–Altrincham section. The station, renamed Sale Moor in 1856, was rebuilt from 1874 to 1877, replacing a wooden building. It became Sale and Ashton on Mersey in 1883 and Sale in 1931, when electric trains were introduced. It closed on 24 December 1991, reopening as a Metrolink station on 15 June 1992.

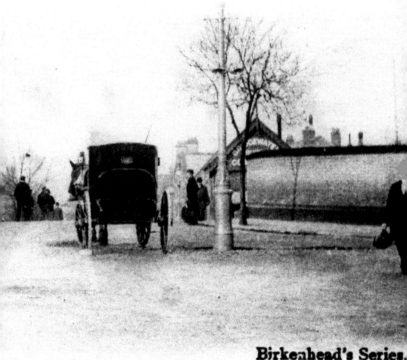

Birkenhead's Series.

29. SALE STATION

In 1903 two things are immediately apparent about the interior of Sale station. The first is that the length of working platform is much greater in 1903 than it is today, probably because demand was also greater and trains, therefore, were longer than Metrolink trams of the twenty-first century. The second is that the station and its gardens are immaculately kept. Today, the buildings along each platform are 'shells,' staff not being necessary for an automated system.

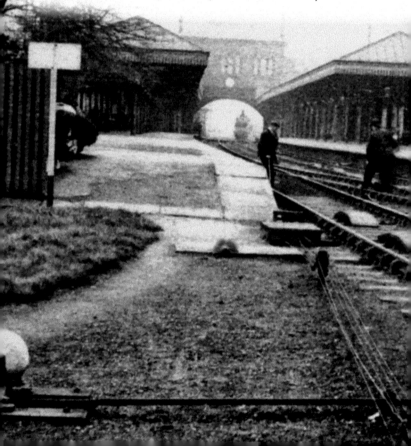

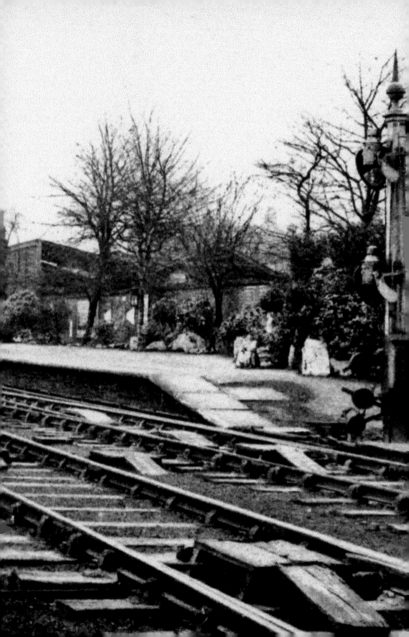

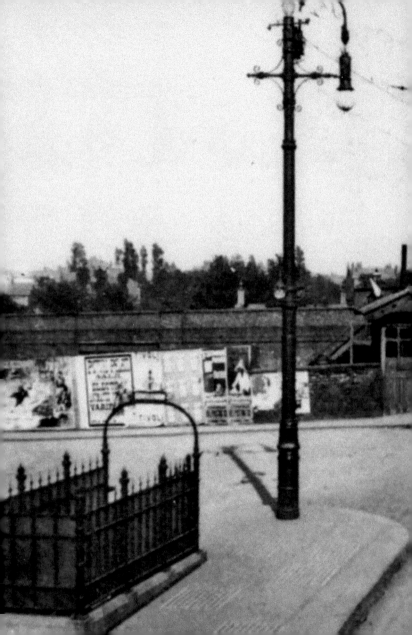

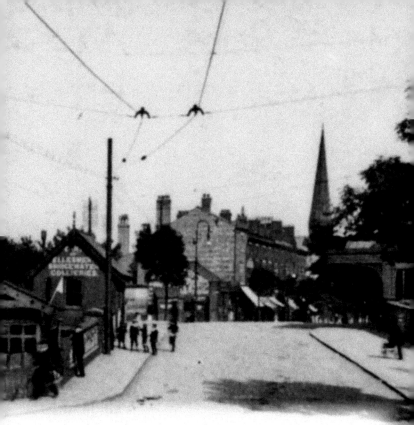

30. SALE BRIDGE

Sale Tramway opened in 1906, and until 1912 the buildings on Sale Bridge, seen in the centre of the photograph, served as the terminus for trams heading into Sale. After 1912 the bridge was widened and the tramline was extended along Northenden Road to the Legh Arms at Sale Moor. The photograph shows Chapel Road to the left and Northenden Road straight ahead. Today, there is a bus stop and a taxi rank along this section of road, as well as traffic lights and a pedestrian crossing.

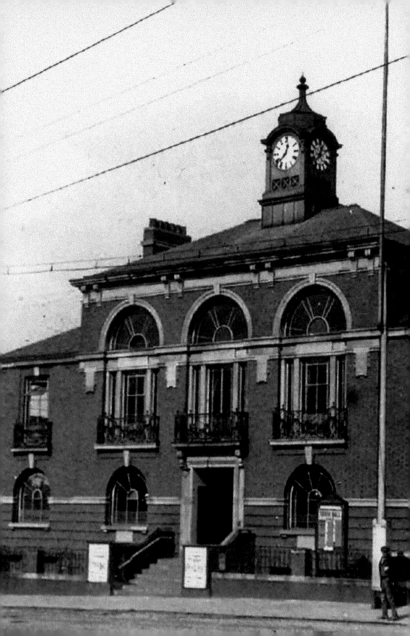

31. SALE TOWN HALL

The foundation stone of Sale Town Hall was laid in May 1914, with the official opening in December 1915. The Town Hall was badly damaged during the Blitz over the night of 23/24 December 1940 and was not fully repaired until 1952. It was extended in 1939–40 and again in 2003. The cenotaph, in front of the Town Hall, was originally located on a traffic island, but later it became part of a widened pedestrian walkway.

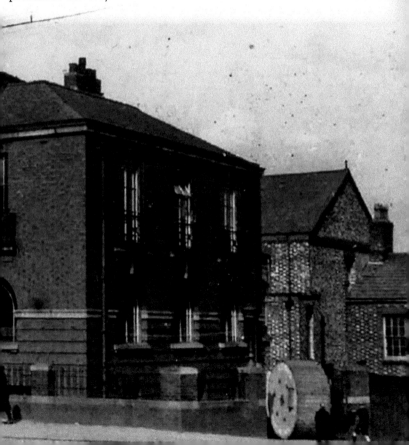

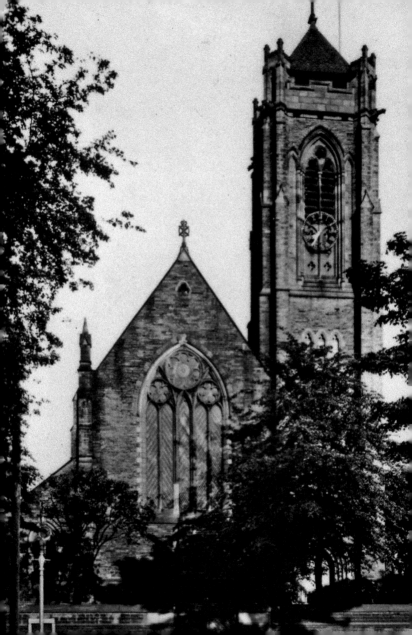

32. ST PAUL'S CHURCH

St Paul's Church was opened in 1883 and consecrated in 1884. It provided seating for 700 worshippers and served the growing communities of the newly developed area surrounding the church. In 1910 the church tower was constructed. However, like Sale Town Hall, St Paul's Church was badly damaged by bombing raids in the Second World War. It is now fully restored to its former state and benefitted from the exterior being cleaned of its grime in 1972.

33. SCHOOL ROAD

School Road's junction with Claremont Road is on the right of the photograph of 1915, which looks towards the junction of Washway Road, Cross Street and Ashton Lane. Stanley Grove is on the left, opposite Claremont Road. The row of shops on the right originally housed Boots the Chemist and WH Smith, both businesses still trading in Sale today. These days there is no trace of the original School Road, which is now completely given over to pedestrians.

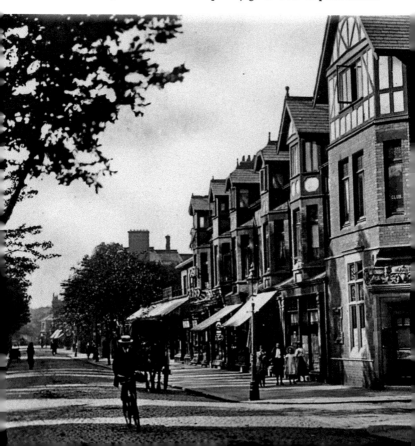

34. WESLEYAN CHAPEL

Wesleyan Methodism became more popular in northern England in the later nineteenth century. This led to the Church of England embarking upon a church-building programme, designed to counter the rise of Nonconformity. The Wesleyan chapel was built in 1860 and demolished in the late 1960s, its worshippers removing to a site on the corner of Wincham Road and The Avenue. It was replaced by the modern retail development that still occupies the site today.

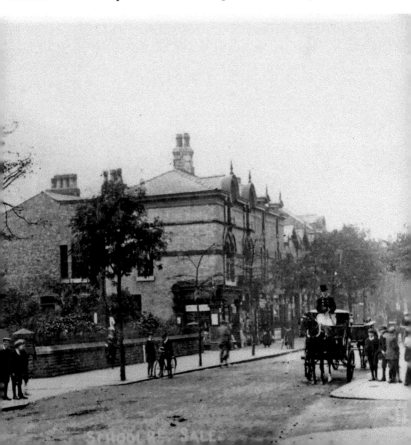

35. SALE FREE LIBRARY AND ART & TECHNICAL SCHOOL

The Free Library opened in 1891, with the Art & Technical School adjoining the library opened in 1897. A cookery room was added in 1902. The front of the old library building was at the junction of Tatton Road and Tatton Place, opposite the police station, with the technical school situated in the building to its left. In 1936 the old library was demolished, with the new building opening in 1938 and today annexed to the Sale Waterside complex, which opened in 2003. Nearby, stood the Savoy Cinema, on Ashfield Road, at its junction with Claremont Road and Tatton Road. The cinema opened in 1913, closed in February 1976 and was demolished in 1985. It is now the site of a car park.

THE INSTITUTE. SALE.

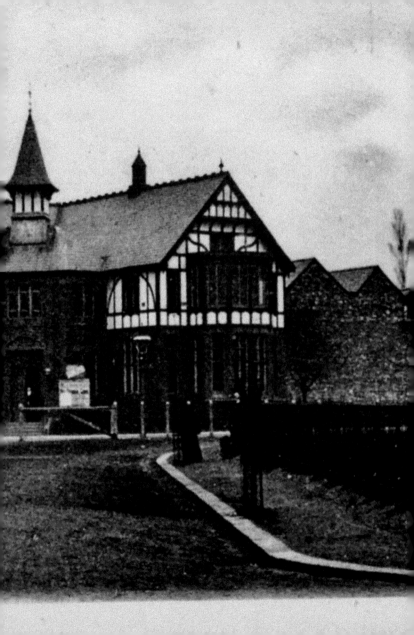

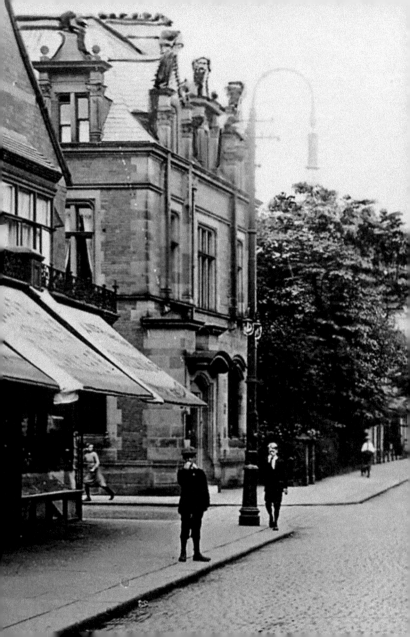

36. SCHOOL ROAD

Parr's Bank stands on the left side of School Road, at its junction with Curzon Road, in this photograph of 1919, which shows the view looking towards Sale Town Hall and railway station, at Sale Bridge. The roadway of cobblestones, or setts, has now gone, with modern paving laid to accommodate the pedestrian. The trees are also much taller today and there is now a pillar box in the middle of what was once the roadway.

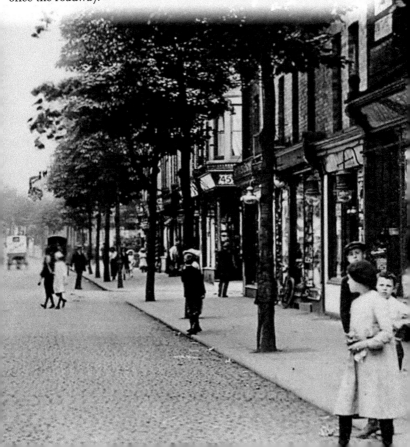

37. PARR'S BANK

At the junction of School Road and Curzon Road, Parr's Bank first came to Sale in 1874. In Slater's Directory of 1914, the manager of Parr's Bank, at No. 70 School Road, was listed as Robert Wall, with the presence of a banking business here emphasising the commercial importance of School Road to Sale. By the mid-twentieth century Parr's Bank had become the National Westminster Bank and later The Bank at Sale restaurant and public house.

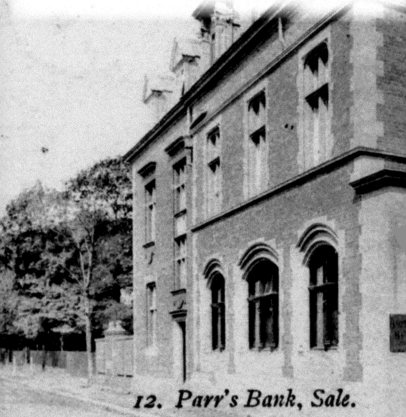

12. Parr's Bank, Sale.

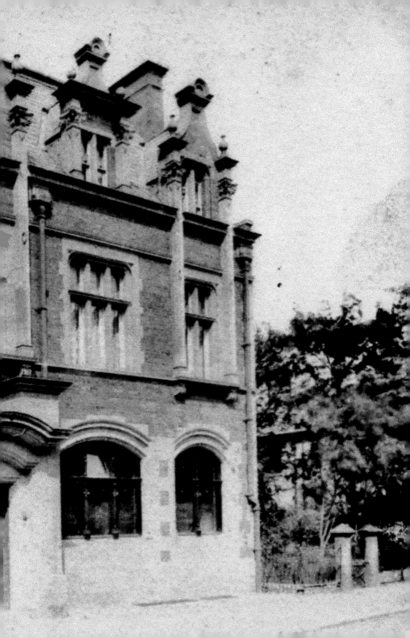

38. HEREFORD STREET

In 1904 Hereford Street was a quiet residential location, while its junction with School Road experienced widespread retail and commercial development. Typical of those artisans trading here was Thomas Dickins, who was recorded as a cabinetmaker and upholsterer with works at Hereford Street and a home address of No. 3 Orchard Place, School Road, in Slater's Directory of 1901. Today, there has been a complete transformation, with modern retail development supplanting the original Hereford Street. Nearby Orchard Place, constructed in 1864, housed three generations of the Dickins family (1864–1924). Only those terraces closest to School Road remain today, however, with the majority being demolished in 1955.

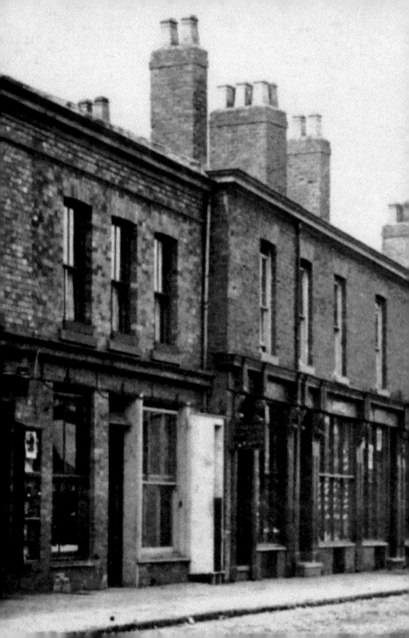

39. SCHOOL ROAD

The building on the left side of School Road, with three gable ends, is still here today. The building attached to it was demolished and a new one, without a garden, was constructed, meaning that Hayfield Street could be widened. The gaslight in the foreground is probably at School Road's junction with Orchard Place. This area of School Road has been extensively altered by modern retail development and the widening of Hayfield Street, which diverts traffic onto Sibson Road.

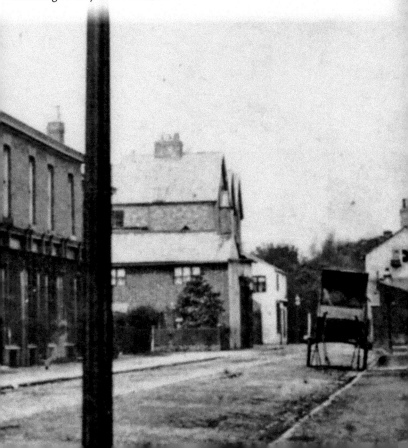

40. WOOLWORTH'S STORE

In 1950 School Road still allowed motor traffic along its entire length and the junction of School Road, Cross Street, Washway Road and Ashton Lane was free of traffic lights. However, today Hayfield Street diverts traffic onto Sibson Road, with traffic lights controlling the safe flow of motor vehicles at the road junction. Woolworth's store is on the far left of the 1950 photograph, trading here until the 1980s. The building has been unoccupied on occasions and was once known as Bar Amp.

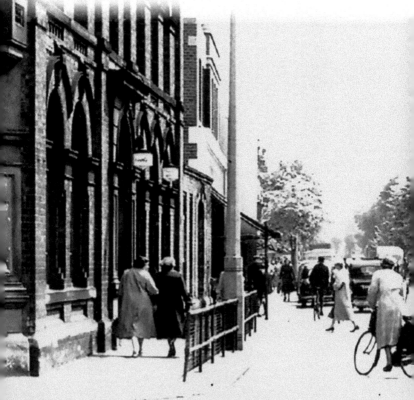

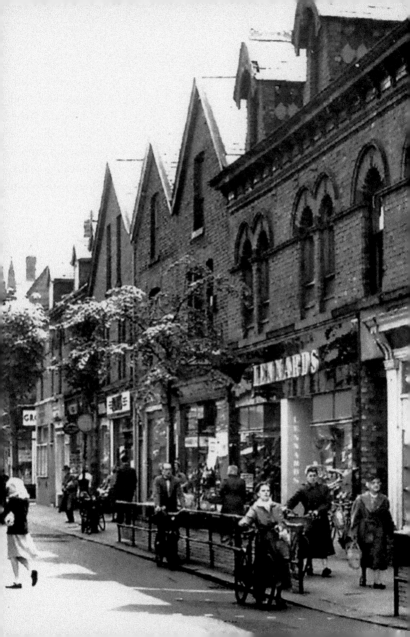

41. SCHOOL ROAD, AT ITS JUNCTION WITH CROSS STREET AND THE BULL'S HEAD

It is believed that Cross Street is named after the existence of a cross that stood on the north end of Crossford Bridge at Stretford. At the other end of Cross Street, on the left of this 1906 photograph, is the Bull's Head Hotel, dating from 1830. It was completely rebuilt in 1879 and remains a major landmark today. To the right of the photograph School Road's junction with Hayfield Street can be seen, which leads onto Sibson Road.

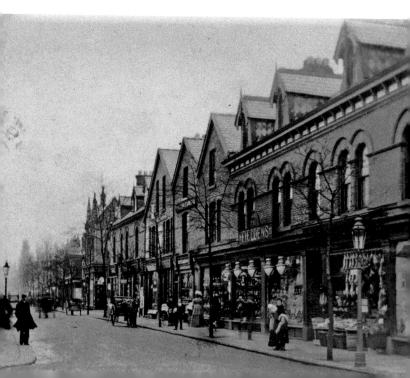

42. ASHTON LANE

The premises on the left of this 1903 photograph and at Ashton Lane's junction with Cross Street is John Clarke's bakery, also dealing in hardware, provisions, tea and coffee. This was a local landmark as was John Ingham & Sons, photographer, on the opposite corner of Ashton Lane and Washway Road, at Winton House. There have been major changes here over the years, with the introduction of one-way systems and traffic lights. The Magistrates' Court, opened in November 1985 by Princess Anne, occupied the site of John Clarke's shop until 2018/19. Retail premises constructed in 1921 occupied the former site of John Ingham & Sons.

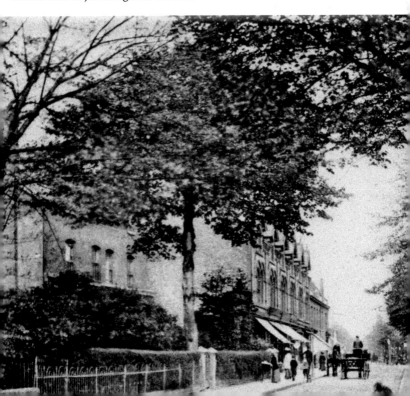

43. ASHTON LANE AT ITS JUNCTION WITH ASHTON GROVE

In 1903 the cottages shown in this photograph of Ashton Lane were fairly typical of the area. This view is looking towards Ashton on Mersey, with Sale Baptist Church on the left. The cottages at the junction of York Road, previously Ashton Grove and Cranleigh Drive, were demolished in 1969 for the creation of a roundabout. Today, this rural idyll has been replaced by a busy road junction, designed to service the one-way system around Sale town centre.

44. NEW PALACE THEATRE

Sale Palace, the first cinema in Sale, was originally Sale Public Hall, built around 1880. In the 1900s it was a roller rink and in 1907 became a theatre. It was known as the Palace from 1909, when films were shown there; it was bought by Warwick Cinemas in 1947 and rebuilt in 1949. After it failed as a repertory theatre the building burnt down in 1962, losing its frontage in 1964. The site is now an office and retail development.

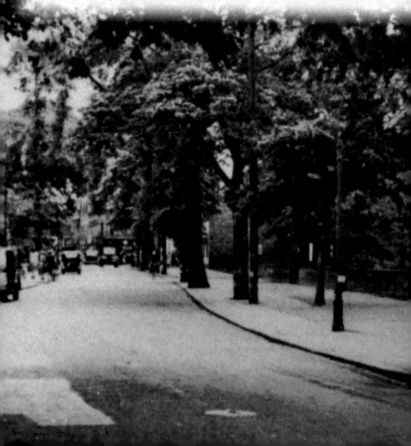

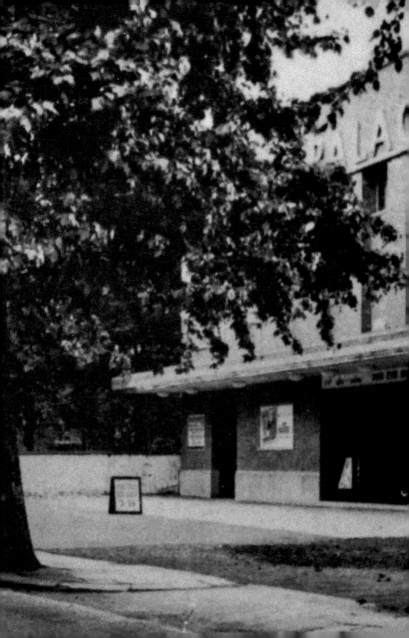

45. ASHTON FOUNTAIN

In 1903 Ashton Fountain can be seen in its original condition. The fountain's gas light provided much-needed illumination at this junction and acted as a local landmark. Also, from the point of view of public utility, it served a valuable purpose as a drinking trough for horses and hosted a post box, both of which can be clearly seen. Today, both have been removed to the pavement, on the Barker's Lane side of Ashton Lane. The cottage on the left is Newton Green House. The fountain was constructed in 1889, financed by William Cunliffe Brooks, son of Samuel Brooks, influential Sale entrepreneur and landowner.

Ashton-on-Mersey

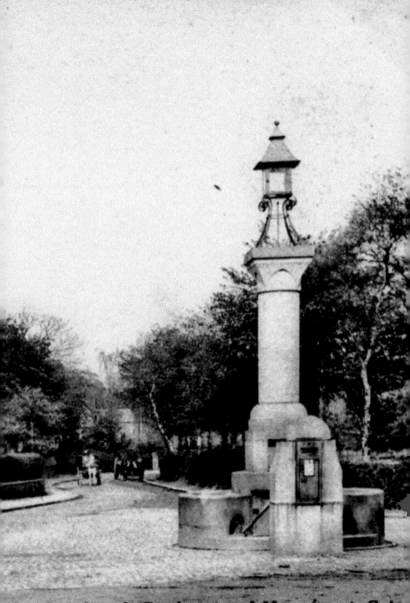

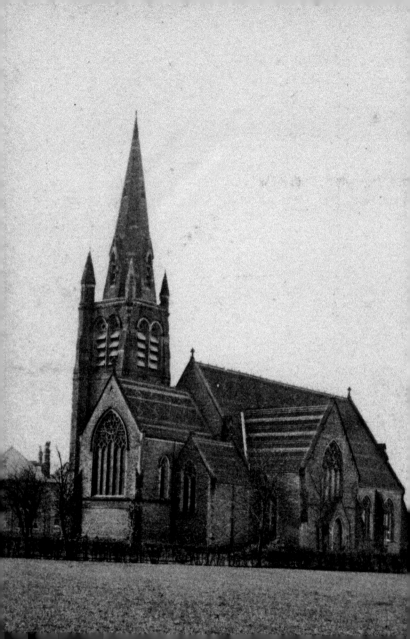

46. ST MARY MAGDALENE

The church of St Mary Magdalene was built by public subscription, costing £9,000 in total. The land was donated by William Cunliffe Brooks, the son of influential banker and Sale landowner Samuel Brooks. It opened on 29 March 1874, eventually becoming a parish in its own right in 1896. The church spire remains a dominant landmark at the corner of Harboro Road and Moss Lane, with the whole area to the north of Washway Road continuing to be essentially suburban and residential.

47. ST MARTIN'S SCHOOL

Located in the centre of Ashton on Mersey, the clock tower was erected in 1874, although the school itself originally dates from 1818 when the Earl of Stamford gave the land for its construction. Today, St Martin's School building has changed very little from this rare postcard view of the late Victorian era. Despite the compromised quality of this photograph, it can be seen that the building has maintained its main features. It is now used for commercial purposes.

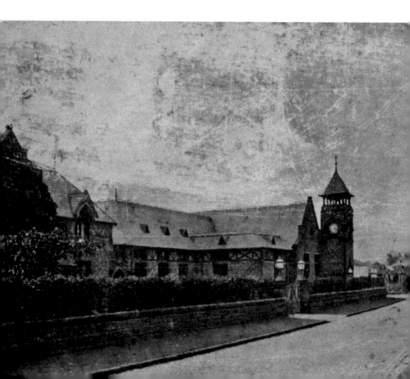

48. THE BUCK INN

The Buck Inn is one of the most historic licensed premises in the district and was constructed in the early eighteenth century. It is a listed building but has not always been a public house, for a time serving as the village gaol. The stocks, now at the churchyard, were originally here and it was the venue for the court leet. St Martin's School is at the far end of the village, with the terrace on its left now rebuilt.

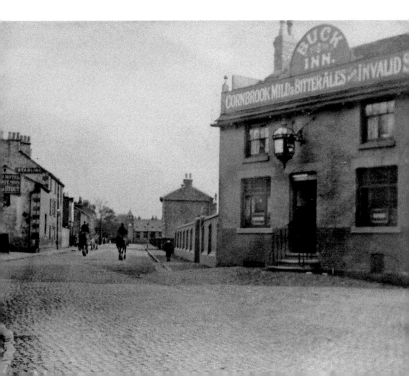

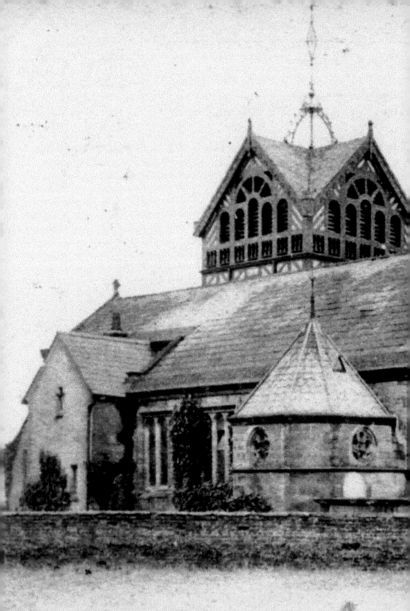

Parish Church. Ashton-on-Mersey.

49. ST MARTIN'S CHURCH

The first church was built in the late ninth century, in the time of the Saxon king Edward the Elder. This was followed by a structure, built in 1304, by Willemus De Salle, the first rector of St Martin's, which was destroyed by a storm in 1704. A new church was built in 1714, near Ashton Old Hall, with additions in 1874 and 1886. In 1887 a new church tower, vestry and lych gate were built, designed by George Truefitt.

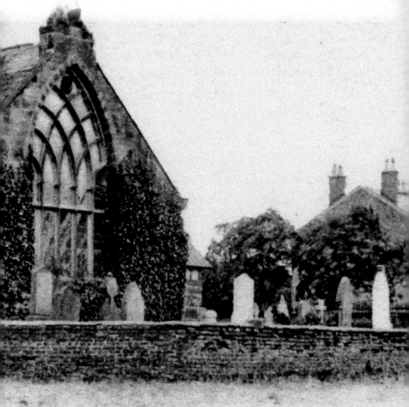

Birkenhead's Se

7. *The Oldest Houses in Ashton-on-Mersey*

50. THE OLD COTTAGE

In 1937 these old thatched cottages were demolished, many years before Church Lane was declared a conservation area. Built in the seventeenth or early eighteenth century and once housing the curates of St Martin's Church, this plot has now been utilised for modern housing. Some of the original buildings surrounding it remain, including the row of terraced housing shown in the background of the photograph. Brick walls on either side of Church Lane in 1903 also remain today. Church Lane is the oldest, most historic part of Ashton on Mersey, near to St Martin's Church, with the junction of Church Lane and Green Lane close to the site of Ashton New Hall.

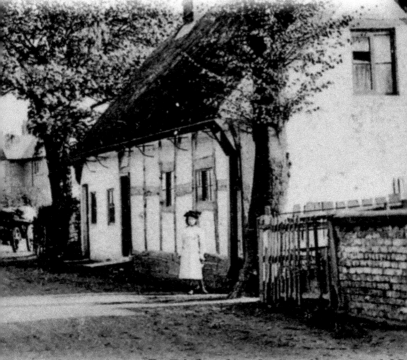

J. Birkenhead, Stationer and N.

BIBLIOGRAPHY

Byron, F. and Partington, M., *Sale in Times Past* (Chorley: Countryside Publications Ltd, 1983)

Dickens, Steven, *Sale Through Time* (Stroud: Amberley, 2013)

Hainsworth, Vivien, *Looking Back at Sale* (Altrincham: Willow, 1983)

Kelly's Directory of Cheshire, 1896 and 1902 editions (London: Kelly & Co., Ltd)

Manchester Archives & Local Studies, Central Library, St Peter's Square, Manchester

The Sale and Altrincham Pages, Parts One and Two

Slater's Directory of Altrincham, Bowdon, Sale, Brooklands & Dunham Massey, for 1899–1933 (Manchester: Slater's Directory Ltd)

Swain, Norman, *A History of Sale: From Earliest Times to the Present Day* (Wilmslow: Sigma, 1987)

Trafford Local Studies Centre, Town Hall, No. 1 Waterside Plaza, Sale, M33 7ZF

ABOUT THE AUTHOR

Steven is a retired charge nurse and college lecturer who now provides full-time caring responsibilities at home. He has previously written for several local history publications, genealogy journals and magazines and has a background in modern history. Steven has also published several *Through Time* volumes, including *Sale Through Time* (2013), and in this *History Tour* of the town continues to study Sale's fascinating past. Steven lives in the Flixton area of Manchester and is married to Sarah. They have three sons and three daughters.